MW00769549

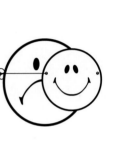

For our daughters: Eve Burkeman, Stella Browd and Emma Browd

Sm;)e

DB Burkeman

Rich Browd

Personal Stories

When I was a kid, my mom was a quasi-hippie. She loved all the symbolism and ephemera that came with hippiedom. I have childhood memories of smiley patches, pins and stickers being adorned to all manner of surfaces. Then, during the '70s, when I was in my late teens and becoming a punk, I, of course, turned against all hippie associations and tropes, thus developing an aversion to the smiley. Fast-forward to the mid-'80s, some of the original punk kids had grown up but were still driven by the punk's DIY spirit, except they were now helping sow the seeds of the acid house and rave explosion by designing flyers, DJing and throwing their own warehouse parties.

By that time, I was a working DJ deeply immersed in this new culture. The smiley had been co-opted by the ravers—but now it was more of a cheeky grin, a wink to others who donned an oversized baggy T-shirt, saying: "We know what's going on, and the outsiders and authorities have no clue!"

DJing and promoting rave nights took me from London to New York, where I made it my mission to bring the U.K.'s underground dance music and its aesthetic to the NYC clubs. I'd met Gary Pini in London, but it was in NYC where Gary was a fixture in the downtown scene and V.P. of Profile Records. In 1991 the label offered me my first A&R gig. Then, in '94, with Profile's green light, Gary and I started our own electronic music imprint, which was to be named after my NYC club night NASA, but my partner in the club tried to force Profile to pay for the use of the name, even though it was a government space agency. So, stoned in Paris one night, Gary came up with the name Sm:)e Communications. It was to be the first time an emoticon was used in a company logo. Later that year Gary and I traveled to England on an A&R mission to meet Norman Cook, a.k.a. Fatboy Slim, at his Brighton home. We were greeted by a mind-bending display of smileys that the musician had been collecting for years, which we've featured in this book.

Now retired from nightlife and mostly confused by a lot of today's popular culture, I've watched the smiley return with a vengeance. Partly fueled by the prolific use of emojis, but also by the insatiable consumption and recycling of pop culture's logos and tropes. Today's youth love and reuse them, regardless of whether the new users know the logos' origins or not: little girls and celebrities wearing the Thrasher logo who have never read the magazine or skated in their lives, hip-hop kids wearing hair-metal or post-punk band shirts. Does it even matter that they have no idea what these bands sounded like or represented? It's all part of this strange cultural cannibalism.

The book you hold in your hands represents Rich Browd's and my love of a symbol that has lived many distinct lives and is still being reinterpreted and inspiring creativity. In the history of graphic design, I can think of no other symbol that has ever held such a duality—used simultaneously as both a positive mainstream driver and a counterculture subverter of that very mainstream.

As I write this, we are in the midst of the worst pandemic in a century, while demonstrations and violence have erupted on the streets in protest of police brutality and systemic injustice towards the Black community. If there was ever a time that this ideogram should be doing its work, it's now. We hope to help you Sm;)e.

DB Burkeman
creator / curator / curious

I grew up enamored with graffiti, skate graphics, and the Pop Art collection of a wealthy friend's parents. The smiley face in some configuration had a funny way of popping up everywhere I looked. The simplicity of the streets' hieroglyphs always left me in awe: the peace sign, the middle finger, the yin-yang, 666, skull and crossbones, the 8 ball and, of course, the smiley. Just two ovals and a half-pipe. Just a few lines carved into a bathroom stall door, etched on the front of Starbucks glass windows or remixed on album covers. Again and again the smiley face glyph was used as a valuable piece of communication. Sure, it might mean "have a nice day," peace, and any other number of uplifting sentiments, but it also began to be used as a tool to communicate the notion "let's disrupt the norm." Let's stick this tab of acid under our headbands and take a trip to a new world full of saturated colors and eggplant Parmesan. Let's cross out the smiley's eyes, let its tongue hang out the side and get a little weird.

Being that it is such a simple mark, it is no surprise that it has been flipped on its head for generations. It's for this reason I'm so very excited to stop, reflect and present to you some of my favorite artists keeping this tradition alive today. Please, remember to Sm;)e.

Rich Browd
artist / vandal / dad

A Little Bit of Smiley History

The factual origins of the Smiley are blurred, but it appears that the oldest known smiling-face artwork was found in Karkamış, Turkey, by a team of archaeologists led by Nicolò Marchetti. When piecing together fragments of a Hittite pot from approximately 1700 B.C., they revealed the face adorned on the outside.

One of the first commercial uses of a smiling face was in 1919, when the Buffalo-Springfield Roller Company applied stickers on receipts with the word "thanks" and a smiling face above it. However, it was quite detailed, similar to a "man in the moon" face.

Many believe it wasn't until 1963, when Harvey Ball was tasked with creating an image that would boost the morale of the employees of the State Mutual Life Assurance Company, that the simple black marks on a yellow background was rendered. There is some debate about whether his was the first simple version. Some believe it began earlier, with the image used by New York's radio station WMCA "Good Guys" in the early 1960s, and there was also a six-minute kids cartoon show called The Funny Company, which aired in 1963, and had a similar smiley in its credits. However, it was not on a yellow background,

Harvey Balls' smiley took him 10 minutes to create and he was paid $45. It looked a little unlike the one we're used to today. Its eyes are narrow ovals, one larger than the other, and the mouth is not a perfect curve. The precise symmetry we're now accustomed to arrived in 1970, when brothers Bernard and Murray Spain, who produced novelty items in Philadelphia, modified the smiley and put it onto buttons with the phrase "Have a nice day." This exploded across America, with the pin and other smiley products being exported and copied around the globe.

Now, this is where the story gets confusing and litigious. In 1971, a clever journalist, Franklin Loufrani, working for French newspaper France-Soir, used the smiley as a way to let the readers know which of the paper's stories held good news. Before he started his campaign, Loufrani registered his own smiley face with the French trademark office, and by the 1990s, he and his son Nicolas held trademarks for the symbol in approximately 70 countries, but apparently not in the U.S.

Regardless of who owns the trademark or copyright, the smiley has shown up in music, books and films that have been major cultural influencers. In 1971, underground comix genius R. Crumb heavily featured the smiley in issue #2 of his comic *Mr. Natural*. In 1977 the Talking Heads single "Psycho Killer" was issued as a 12" in Europe with a sleeve showing the torso of a man wearing an oversized and distorted smiley on his T-shirt. 1979 saw the Dead Kennedys release their debut single, "California Über Alles." The sleeve had a collage with California governor Jerry Brown in front of a Nazi rally. The swastikas on the banners were replaced by smileys.

This smiley/swastika banner idea was used to great effect in 2003, when the controversial but brilliant British artists Jake and Dinos Chapman staged *The Rape of Creativity*, draping actual massive red, black and white banners emblazoned with the smiley down the front of the exhibition space. In their 2011 exhibition, *Jake or Dinos Chapman*, the brothers continued and developed the idea by giving their life-size Nazi SS sculptures smiley armbands. In their *Come and See* show in 2013, they created full-size Ku Klux Klan

figures, with smiley patches on their white hooded gowns in place of the KKK insignia. The effect of this happy, innocent design being used by such evil characters is truly jarring.

Since the late '70s, Hollywood costume designers and prop departments have placed the smiley in movies as patches, stickers, pins, posters or painted on vehicles. The list is endless, but some notables are: Matt Dillon's debut, *Over the Edge* (1979), *Paris, Texas* (1984), *Stranger Than Paradise* (1984), *Friday the 13th Part VI: Jason Lives* (1986), *Empire Records* (1995), *Billy Madison* (1995), *The Prophecy* (1995), *Half Baked* (1998) and *The Virgin Suicides* (1999).

In 1987 under a carpark in a fitness center in central London, a new club night called Shoom used a hand-drawn smiley on its flyer and later its membership card. DJ and promoter Danny Rampling wanted to convey "what this movement is all about — big smiles and positivity." From there the symbol went on to sweep the nation for the next few years as the face of the rave movement. By 1992 the rise of rave culture had spawned several musical subgenres and scenes. One that really took off in its own right was called hardcore, a music made up of hyper-frenetic breakbeats, with techno as its foundation. One of the biggest record labels of the hardcore scene, Suburban Base, had a resident visual artist, Dave Nodz. He created a superhero-comic-style character that had a smiley ball for a head, which was featured on several record covers.

Back in the U.S., issue #1 of Alan Moore and Dave Gibbons' 1986 literary and graphic masterpiece *Watchmen* showed the Comedian's blood-splattered smiley pin on the cover, and as an important visual signal within the story. Then, in 1991, Kurt Cobain and Nirvana gave the smile a new, darker twist, when a wonky hand-drawn version was used in the campaign for the band's seminal, world-crushing *Nevermind* LP, and then became the iconic T-shirt. In 1993, to promote the '70s period film *Dazed and Confused*, the studio simply used a smiley on the advance poster, with the words "Have A Nice Daze." In 1994, the feel-good Hollywood tearjerker *Forrest Gump* presented us with the fictitious idea that the smiley was created by Forrest's sweat-and-mud-covered face being wiped on his T-shirt. The icon shows up in TV shows too. Matt Groening is a fan, including it in his early cartoons and many episodes of *The Simpsons*. *The X-Files* featured smileys in the '80s and '90s, and then David Duchovny carried on the tradition by wearing a big smiley shirt on his 2000s show *Californication*. When the *The X-Files* relaunched, in a 2016 episode, the writers couldn't resist turning the scary clay monster's face into a smiley.

Recent uses in music include in 2012, co-director Terence Neale's clever use in Die Antwoord's "Baby's On Fire" video. In 2015, in the video for "Blackstar," David Bowie has a smiley patch on his spacesuit in his final, sad and epic gift to us. And in 2019, Mac DeMarco used nothing but a smiley button on the cover of his LP *Here Comes the Cowboy*.

Recently the symbol has increasingly become a part of the hip, high and low-end fashion worlds, being utilized — sometimes licensed, other times not — and adorning all manner of clothing and objects, from hoodies to basketballs and lamps.

Who knows what the future holds for smiley? With the world so upside down, we simply hope that artists and designers keep being creatively inspired to use it!

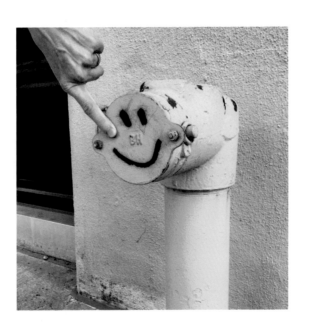

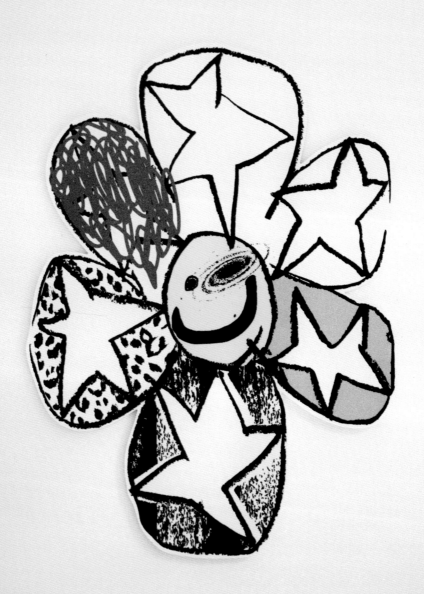

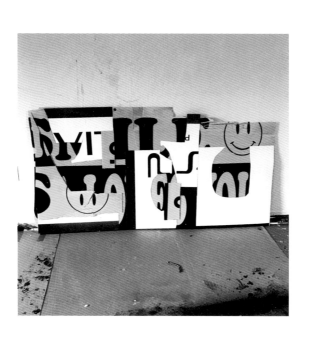

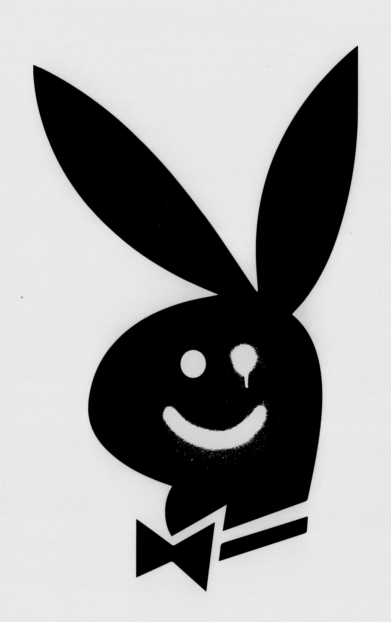

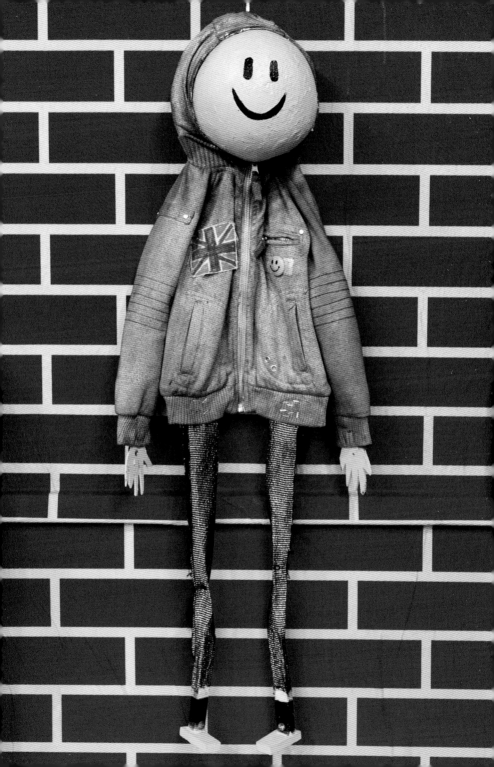

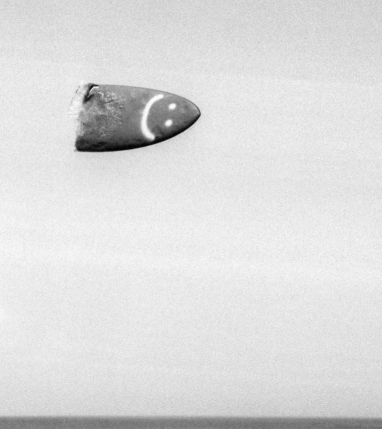

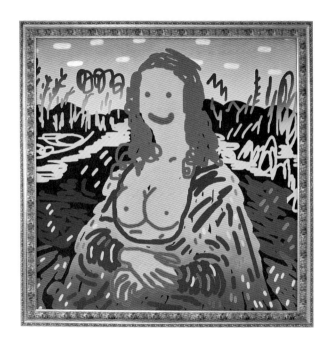

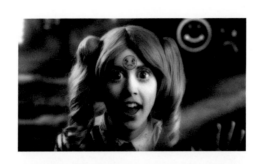

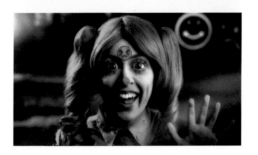

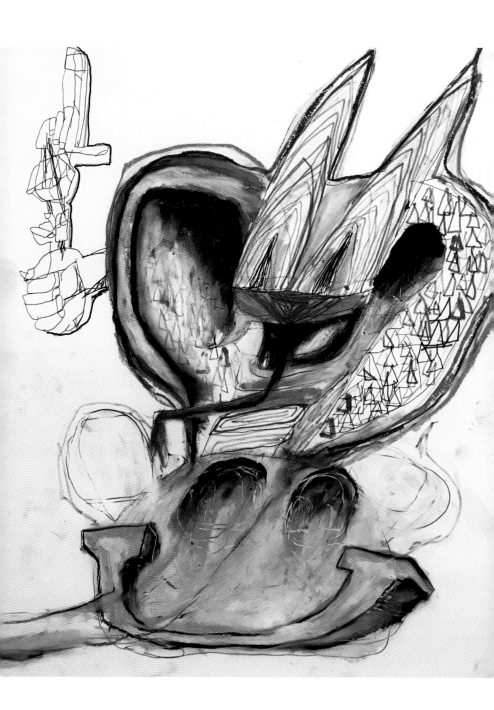

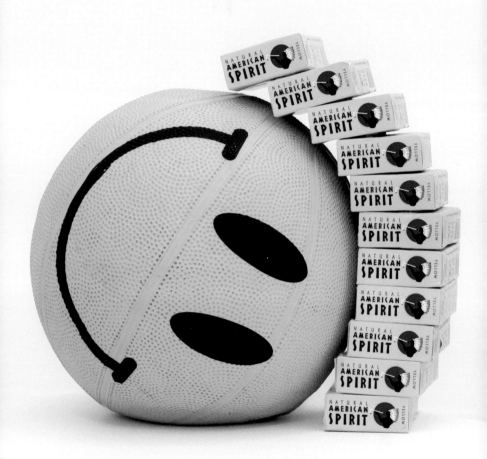

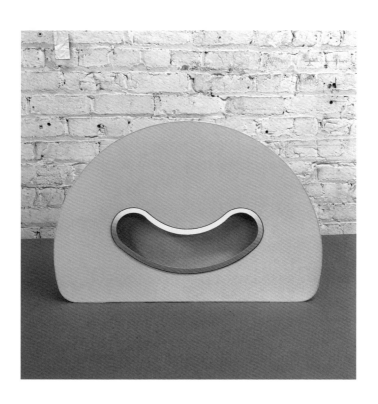

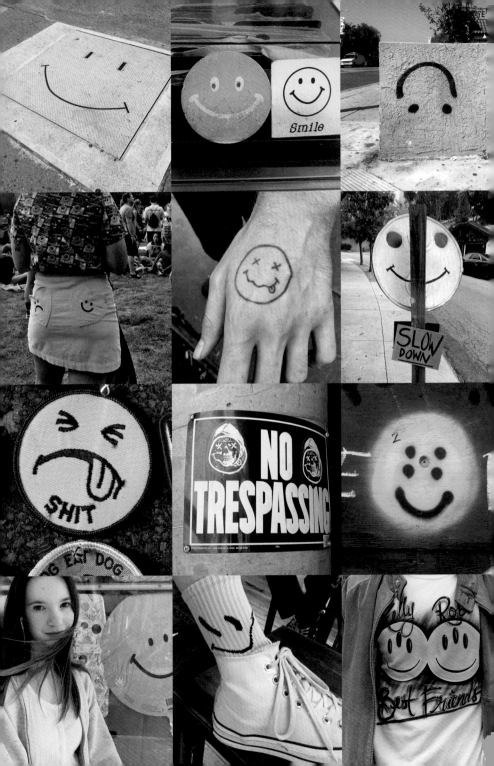

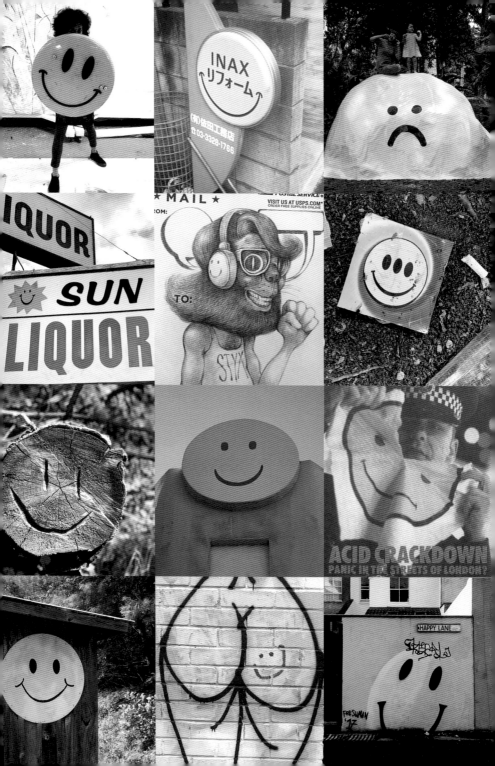

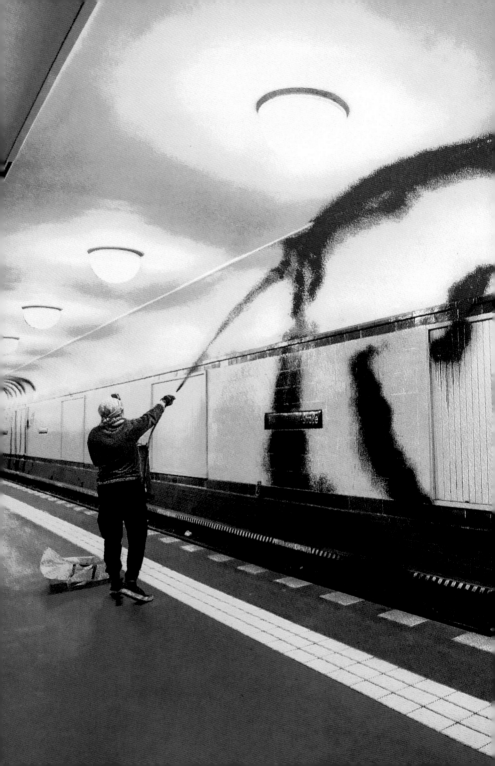

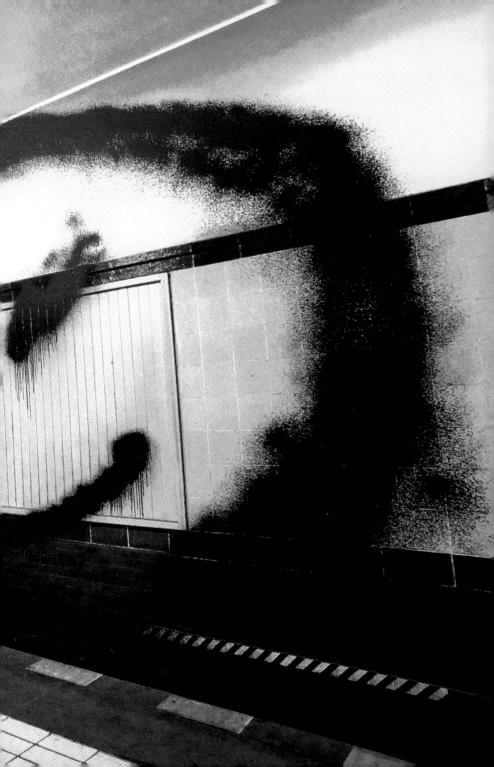

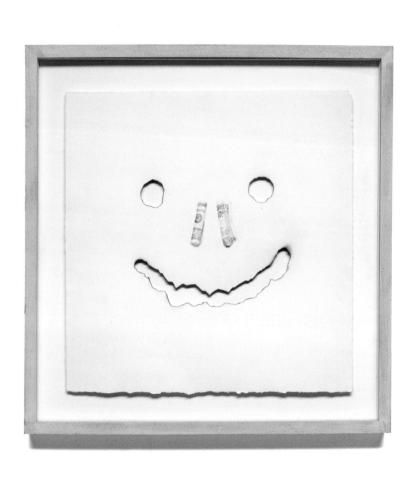

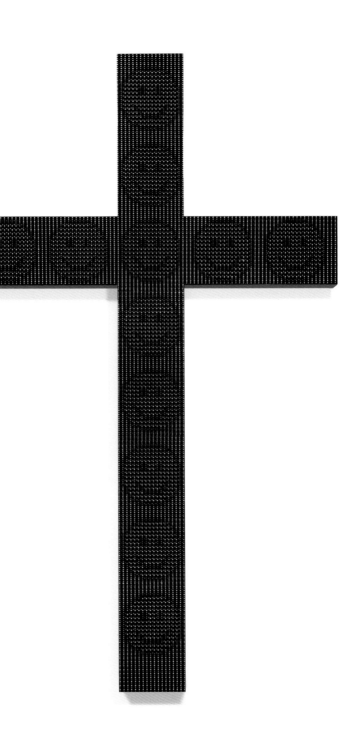

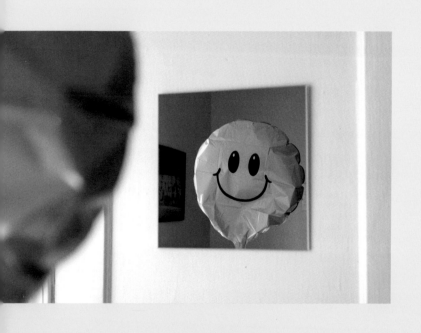

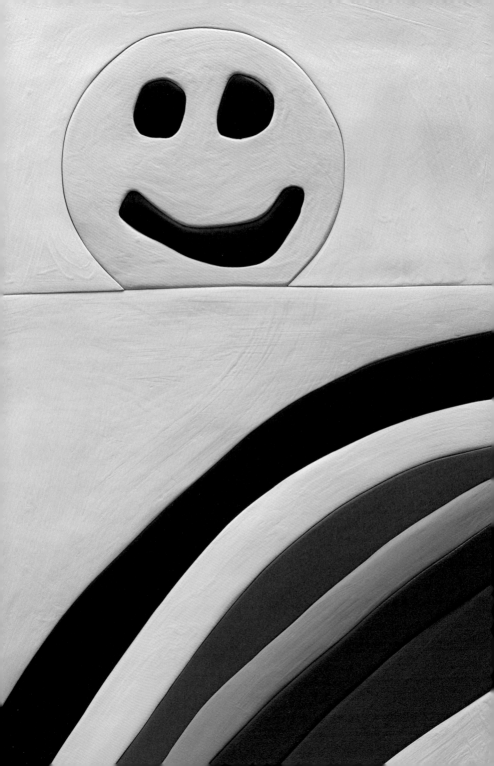

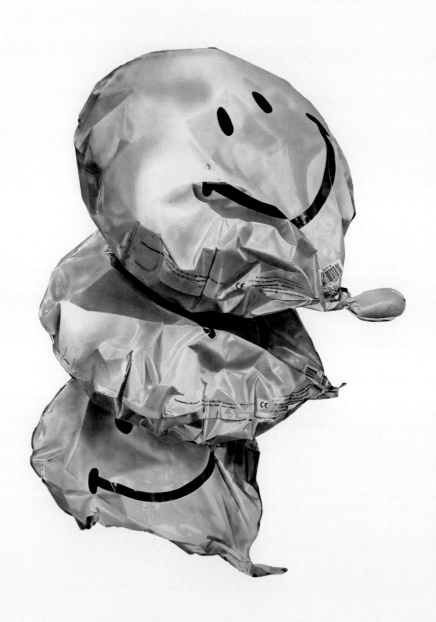

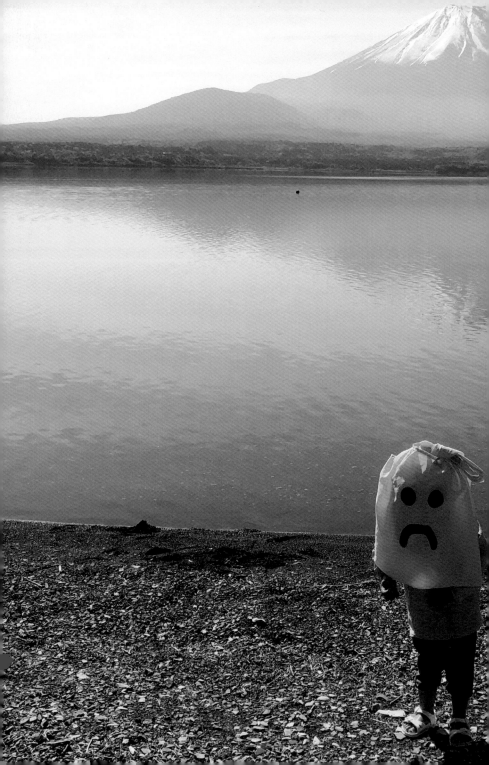

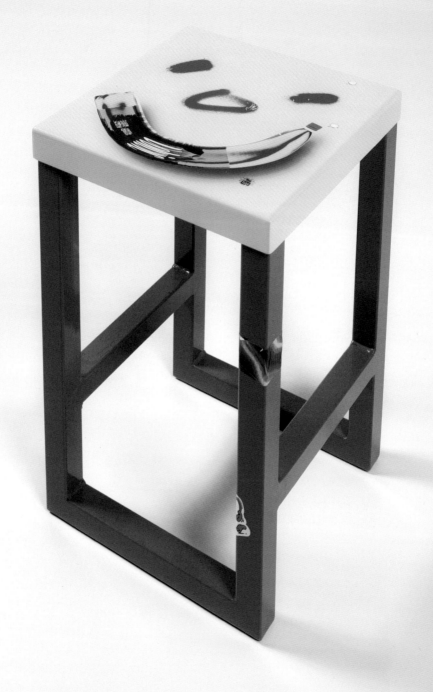

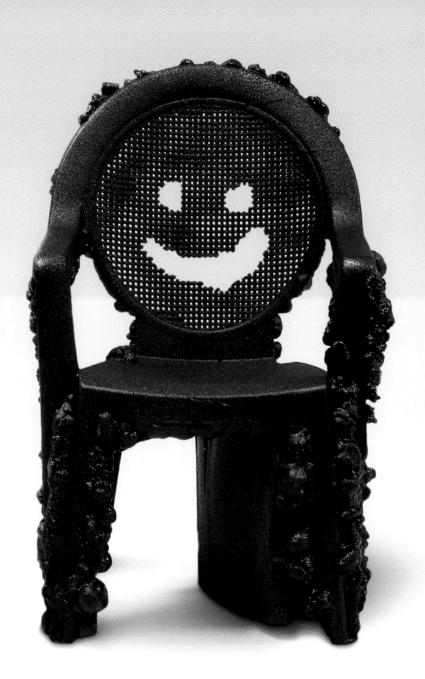

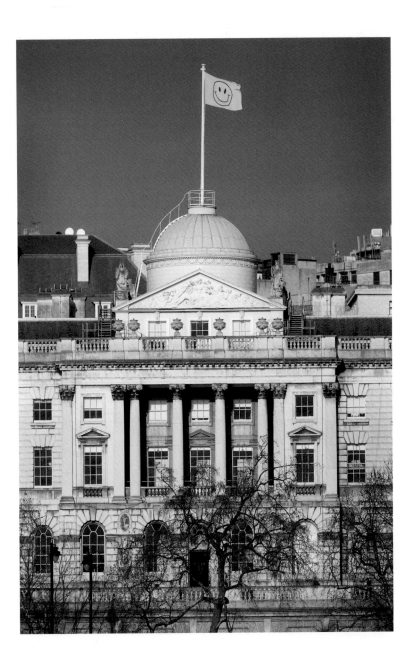

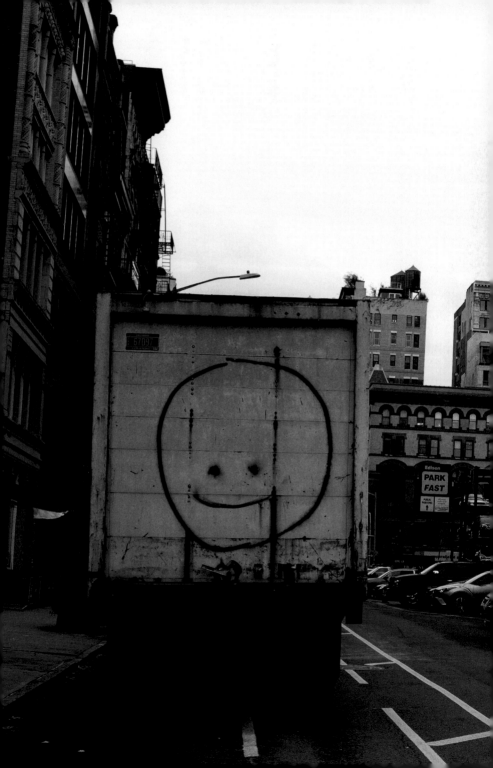

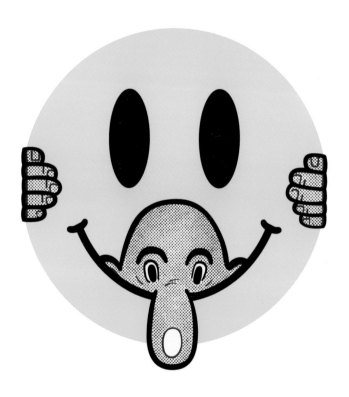

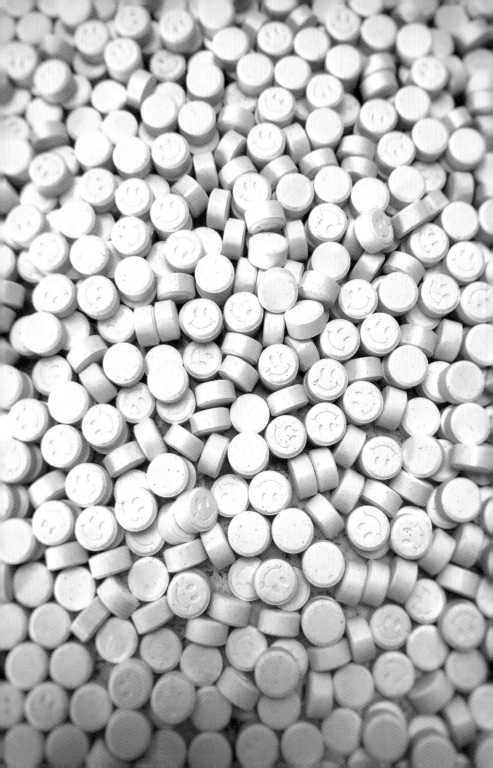

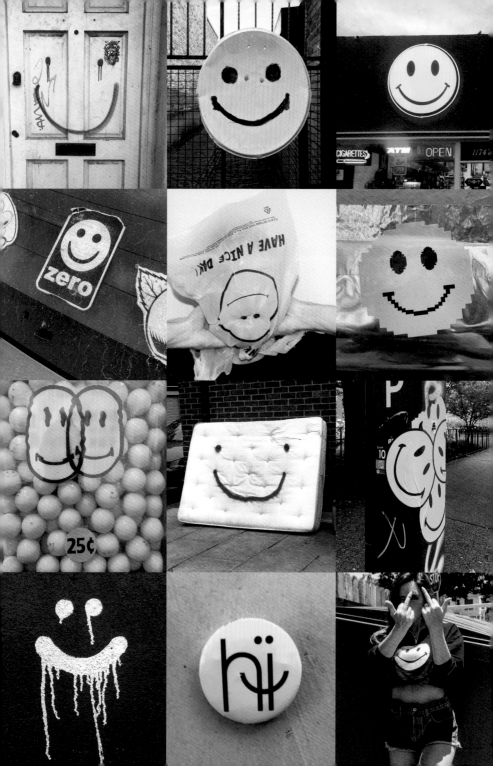

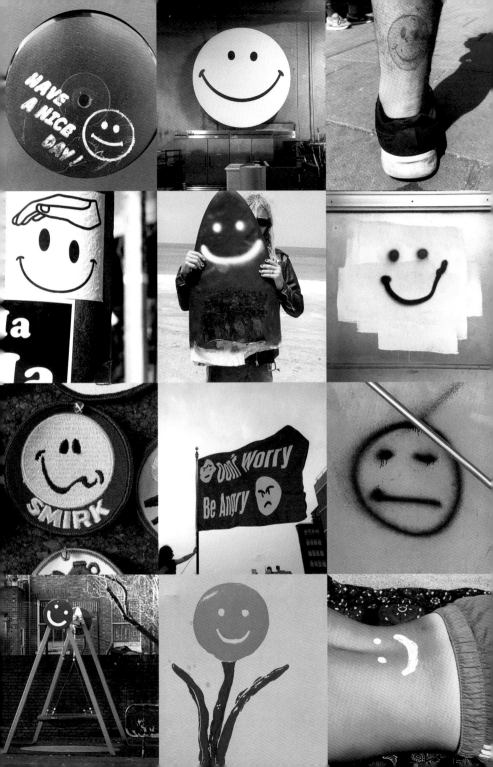

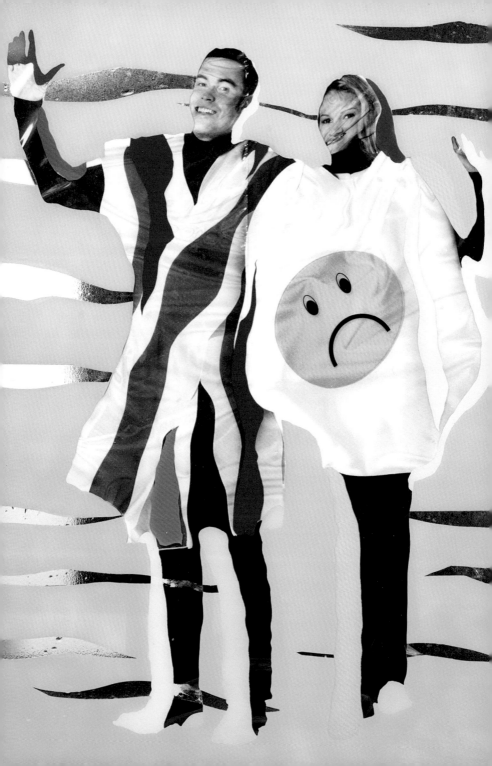

If you're feeling run down after taking acid, ecstasy or speed call 0800 888 088 for help.

NEW
RETAIL & OFFICE
DEVELOPMENT

SHOP UNIT 1 400 SQ.FT.
SHOP UNIT 2 600 SQ.FT.
A2 UNIT 3 620 SQ.FT.

OFFICES 600-4000 SQ.FT.

FOR SALE OR TO LET

ALMA ROAD JIRIES
(020) 99300

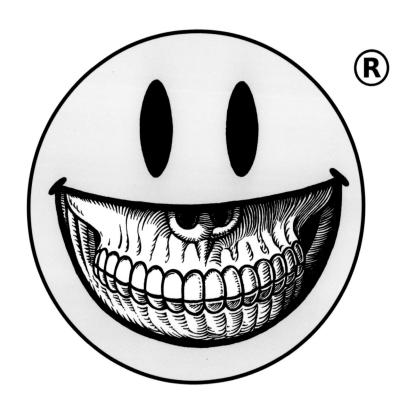

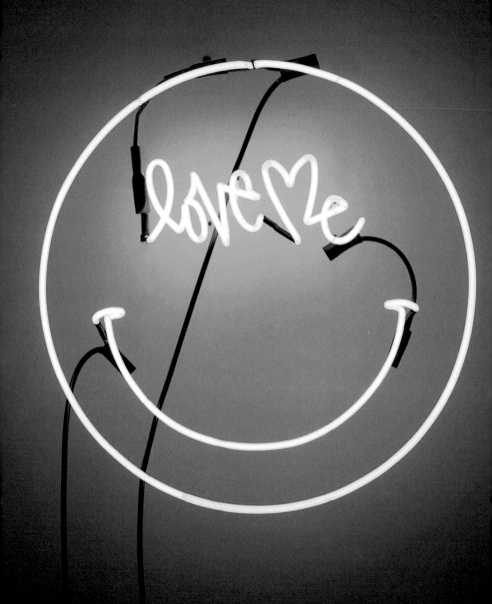

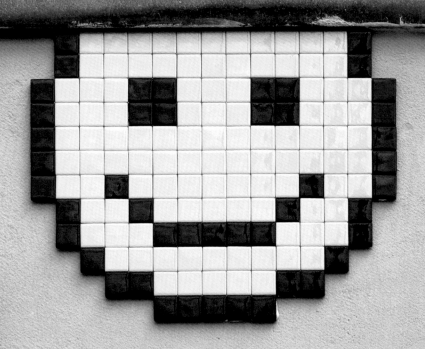

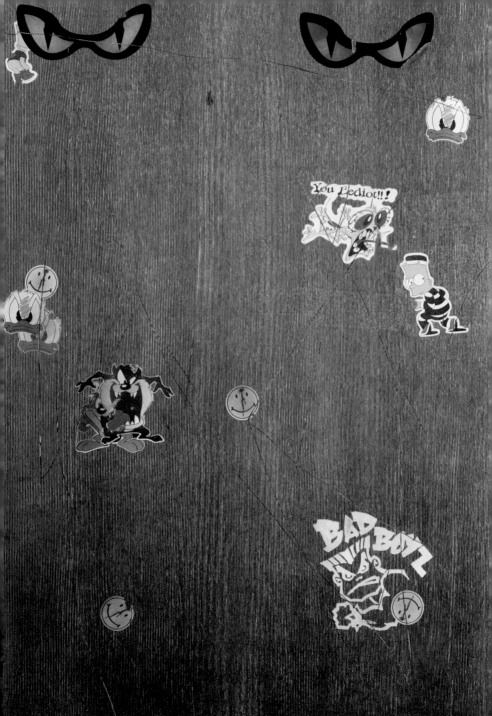

SHIT ANGRY YOUNG MAN ALWAYS
MAKE THE NIGHTMARE COME TURE

糞 青

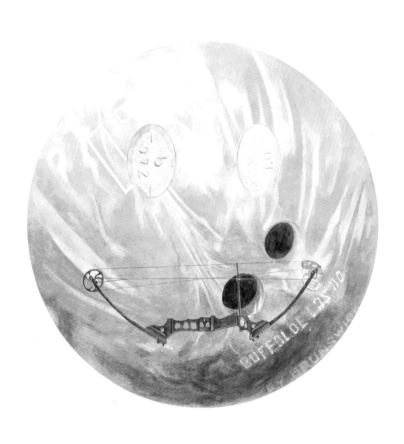

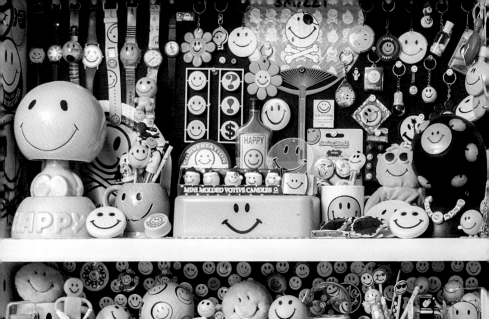
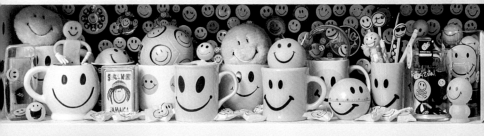
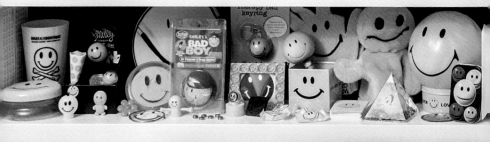
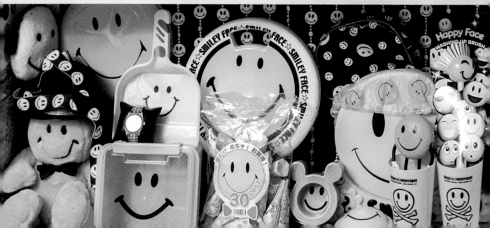

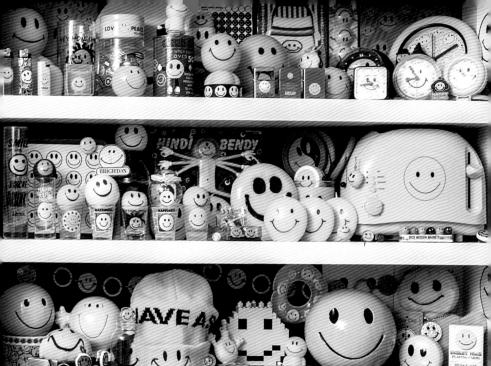
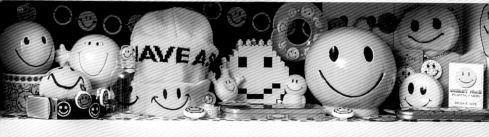
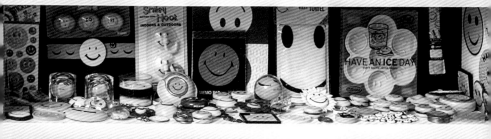
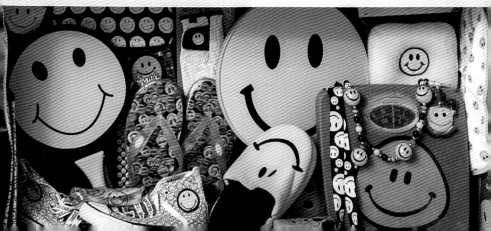

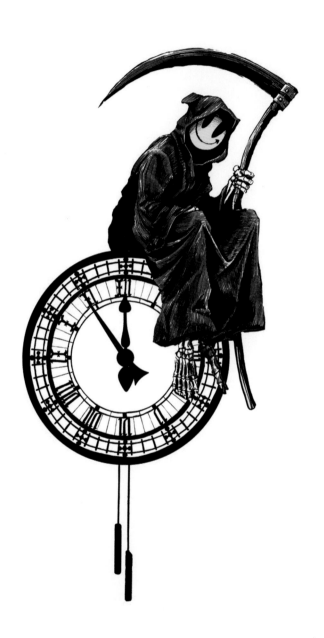

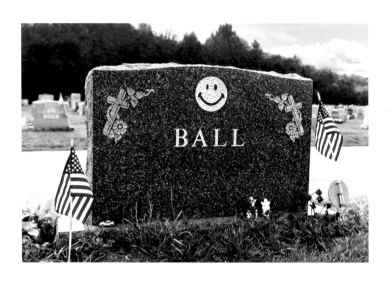

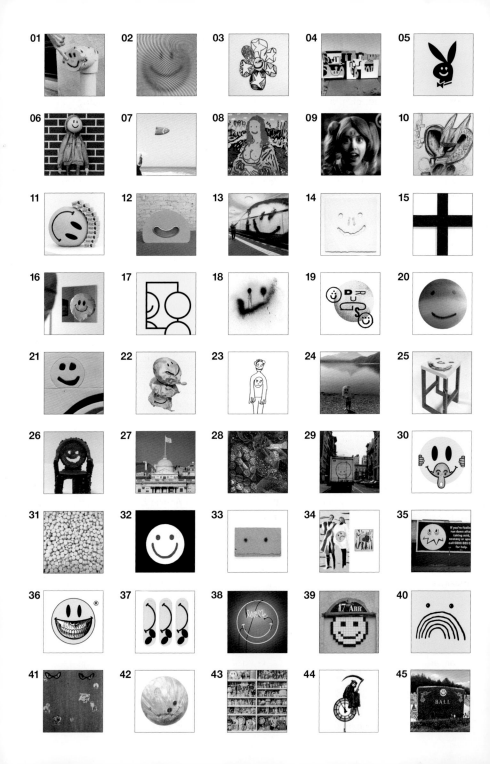

01 DB Burkeman "It's rude to point" 2017 Photograph **02 Alex Trochut** "XANAX" 2013 Print (New York Mag) 8 x 10 in. **03 Chris Alborano** "Short of a Season" 2019 Silkscreen on custom panel 60 x 44.3 in. **04 Mark Flood** "Play Station" 2020 Cut and pasted printed plastic and Coroplast 37 x 72 in. **05 Rich Browd** "Come Here Often?" 2018 **06 Paul Insect & BÄST NY** "Acid Boy" 2015 Fabric, football, wood, glue, staples, spray paint 37.5 in. **07 @INMINDSEYE** Photograph. 2015 **08 Philip Gerald** "Few People Know Anything About This Famous Painting By Leonardo DiCaprio [Abbreviated Title]" 2018 Acrylic & airbrush on canvas 35.43 x 35.43 in. **09 Rachel Maclean** Two stills from digital film *Feed Me*. 2015 **10 Erik Foss** "Don't play with sticks that rattle" Oil, acrylic, pen, pencil, Sharpie, on canvas 40 x 30 in. 2020 **11 Tyrrell Winston** "Sitting Sideways In My Uber While Sipping a P.B.R." 2018 Found basketball, found American Spirit packages, silicone. Dimensions variable **12 Greg Bogin** "Greetings" 2019 Acrylic and ink on paper on paper board 12 x 18.5 x 3 in. **13 1UP CREW** "Keep Smiling" 2018 Printed by Dolly Demoratti (Mother Drucker) Edited by Urban Spree Prints, Berlin 19.75 x 27.5 in. **14 Aurel Schmidt** "Sniffy" 2007 Graphite and colored pencil on paper 15 x 15 in. **15 SKULLPHONE** "#29 Happy Face" 2011 Urethane base, polyurethane clearcoat and enamel on aluminum panel with hand painted dots 36.5 x 60 x 2 in. **16 Anthony Sarcone** "Are You Happy" Inkjet print on paper 13 x 19 in. 2019 **17 Alex Fuller** "You Are Beautiful" 2017 Vinyl sticker 2 x 2 in. **18 KATSU** "Facial Recognition Just Released From Jail" 2015 Enamel on canvas 36 x 36 in. **19 Rich Browd** "Just Say No" 2020 **20 Rob Pruitt** "Untitled" 2018 Sharpie on rubber kickball 10 in. diameter. **21 Sadie Benning** "Smiley Face" 2016 (detail) Wood, aqua resin, casein, acrylic gouache 60 x 34 in. Photo: Chris Austin **22 Carlos Valencia** "Untitled" 2020 Graphite on paper 48 x 36 in. **23 Richard Prince** "Untitled (Hippie Drawing)" 1998 Marker on paper 11 x 8.5 in. **24 Misaki Kawai** Photograph, Mt. Fuji. 2018 **25 Yung Jake** ":o)" 2016 UV print, spray paint and tape on powder-coated steel 23 x 14 x 14 in. **26 Matthew Nichols** "Smiles Chair" 2020 Polystyrene, plastic & rubberized plastic 36 x 24 x 24 in. **27 Jeremy Deller & Fraser Muggeridge** "Flag for Utopia" 2016 Photograph Peter Macdiarmid / Getty for Somerset House. Season at Somerset House **28 Destroy All Monsters/Cary Loren** "Virgil's Happy Night" 1978 (Insert for DAM Magazine, Issue #5) Color Xerox 8.5 x 11 in. **29 Derek Gardner** "Untitled" 2019 Photograph **30 Eric Elms** "Wish You Were Here" 2013 **31 IMBUE** "Happiness Pills" 2018 Pressed pills. Photograph. **32 Jake and Dinos Chapman** "Chapman Smile" Size variable, Medium variable, Year variable **33 Alicia McCarthy** "Untitled" 2018 Acrylic and spray paint on found MDF panel 21.2 x 20.5 in. **34 Alex Da Corte** "Untitled" (Bacon and Eggs: Made in Heaven (after Michelangelo's Last Judgement) 2014 Plexiglass, mirror adhesive paper, sheer nylon, spray paint, Mylar, foam, sequin pins, vinyl decal, velvet, anodized metal frame 64 x 56 x 1.5 in. / "Untitled" (Peanut Butter and Jelly: Made in Hell (after Michelangelo's Last Judgement) 2014 Plexiglass, photo gels, sheer nylon, spray paint, Mylar, foam, sequin pins, vinyl decal, velvet, anodized metal frame 64 x 56 x 1.5 in. **35 Wolfgang Tillmans** "untitled (if you're feeling down)" 1991 Photograph **36 Ron English** "Grin" 2008 Oil on canvas 10 x 10 in. **37 James Joyce** "Untitled" 2016 Plywood, paint 32.28 x 7.8 in. **38 Curtis Kulig** "Yellow Smile" 2018 Neon 24 in. **39 INVADER** "PA_1159" 2015 Ceramic tiles on street in Paris **40 Cody Hudson** "Long Day" 2016 Computer colorized ink drawing 5 x 8 in. **41 Sayre Gomez** "Shit angry young man always make the nightmare come ture" 2018 Acrylic on canvas 36 x 24 in. Photo by Kell Yang-Sammataro Courtesy of the Artist and François Ghebaly, Los Angeles **42 Alfred Steiner** "Smiley Face" 2011 Watercolor on paper 21.5 x 29.5 in. **43 Norman Cook** Photograph Mark Vessey. 2019 **44 BANKSY** "Grin Reaper" 2005 Screenprint: edition of 300 27.5 x 17.12 in. **45 Katlyn Reilly** Photograph. 2020

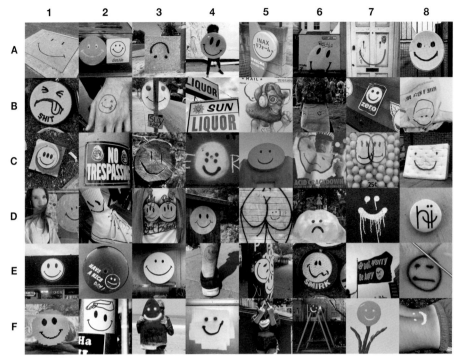

DB Burkeman: A(1,2), B(6), C(1,6,7), D(1,3), E(2), F(1) **Rich Browd:** A(3), B(1,2,3,4,7,8)C(2,4,5), D(4,5), E(6,8), F(7) **James Cauty** Photo: **Alannah Currie:** A(4) **Paul Wig:** A(5) **@smileyfac.e:** A(6,7,8), D(3,6), E(4)F(6,8) **Patrick Rocha:** B(5) **Gabriel Hunter:** C(1) **Cozette McCreery:** C(8) **Ryan Bramwell:** C(3) **Misaki Kawai:** D(6) **Chris Peck:** D(2) **Brad Schwartz:** E(1) **Matt Lenski:** E(3) **Paul Weston:** F(2) **@INMINDSEYE:** F(3) **Zach Britt:** E(5) **Jeremy Deller:** E(7) **Tom Carnase:** D(2) **Derek Schiller:** F(5)

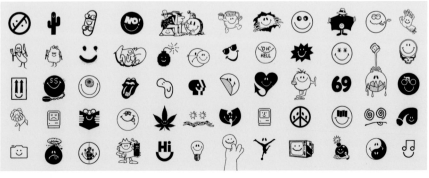

Jeremy Beson "Black Flag" (2014), **Andreis Costa** "YME" (1981), All others by **Rich Browd**

Special Thanks

Aaron Pierce, Alexandra Zotov, Amanda Bessette, Anika Jamieson-Cook, Dan Ipp, Daniel Sharp, Danny Rampling, Davina Bhandari, Dominik Lochmann, Edward Helmore, Frances Teehan, Gan Uyeda, Garry Blackburn, Gary Pini, Jonathan Hoyt, Justin Waldron, Justine Ludwig, Kate Morrell, Katherine Murphy, Kathy Grayson, Katy Ellis, Kristen Smoragiewicz, Matt Shuster, Matthew Higgs, Mikkel Grønnebæk, Minka Marcom, Natasha Logan, Nelson Harst, Nina Chiofalo, Paolo Ripamonti, Pascal Feucher, Patton Hindle, Pest Control, Roger Gastman, Silke Lindner-Sutti, Stephanie Adamowicz, Tarssa English, Tim Livezey, V I N C E fine arts/ephemera

Extra Special Thanks

Alannah Currie, Alex Da Corte, Alex Fuller, Alex Trochut, Alfie Steiner, Alicia McCarthy, Andreis Costa, Anthony Sarcone, Aurel Schmidt, BANKSY, BÄST, Brad Schwartz, Carlos Valencia, Cary Loren, Chris Alborano, Chris Austin, Chris Peck, Cody Hudson, Cozette McCreery Curtis Kulig, Derek Gardner, Destroy All Monsters, Eric Elms, Erik Foss, Fraser Muggeridge, Gabriel Hunter, Greg Bogin, IMBUE, INVADER, Jake & Dinos Chapman, James Cauty, James Joyce, Jeremy Beson, Jeremy Deller, Jock Dredge, Katlyn Reilly, KATSU, Mark Flood, Mark Vessey, Martha Cooper, Matt Lenski, Misaki Kawai, Norman Cook, Patrick Rocha, Paul Insect, Paul Weston, Paul Wig, Peter Macdiarmid, Philip Gerald, Rachel Maclean, Richard Prince, Rob Pruitt, Ron English, Ryan Bramwell, Sadie Benning, Sayre Gomez, SKULLPHONE, Stateless Collective, Tom Carnase, Tyrrell Winston, Wolfgang Tillmans, Yung Jake, @smileyfac.e, 1UP CREW

Edited by
Rich Browd + DB Burkeman

Logistics
DB Burkeman + Zach Britt

Design
Rich Browd + Christi Catalpa